Copyright © 2017 Dea Bernadette D. Suselo
All rights reserved.

ISBN: 9781096189817

www.facebook.com/DeaBernadette
Instagram: dea_bernadette

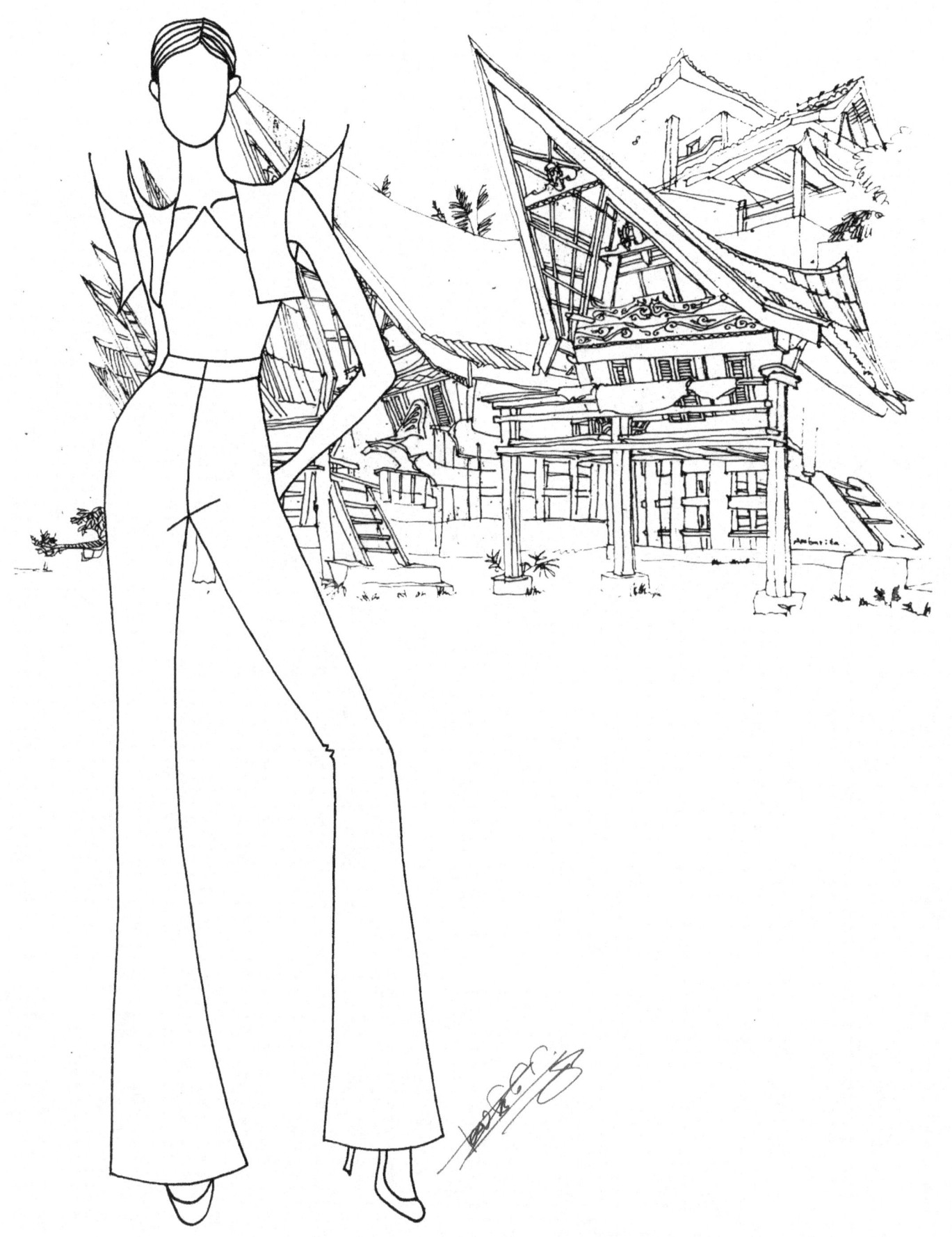

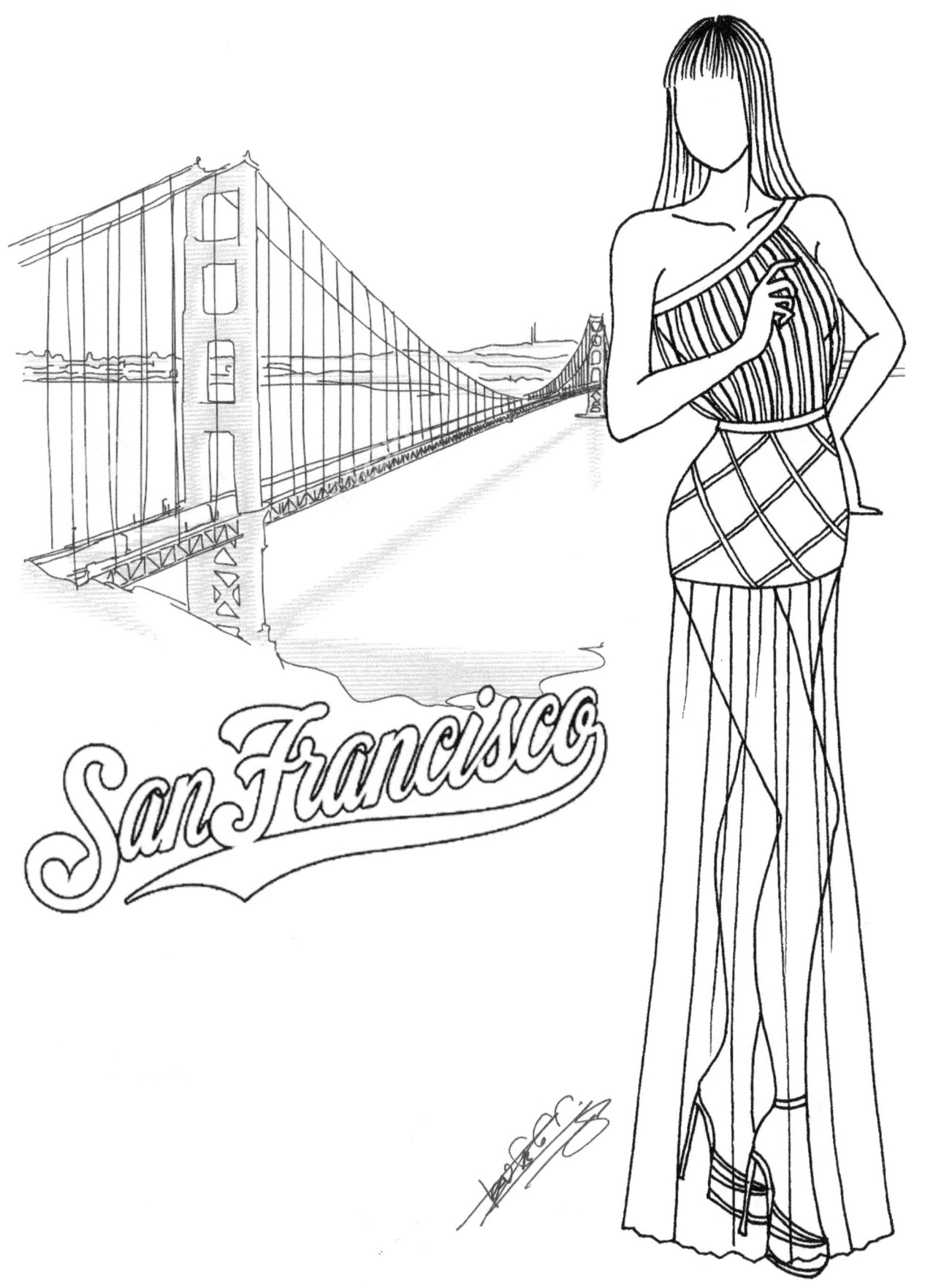

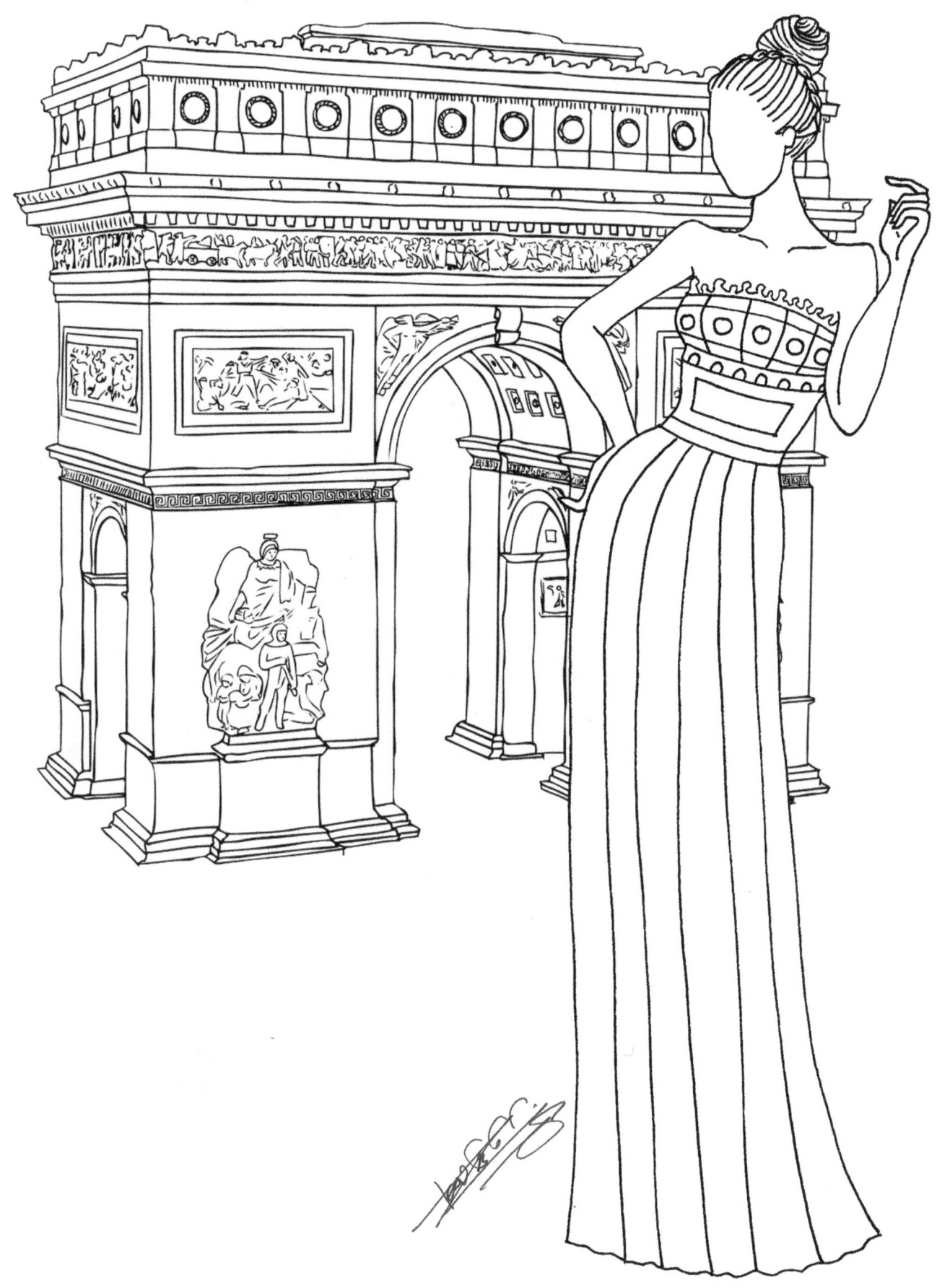

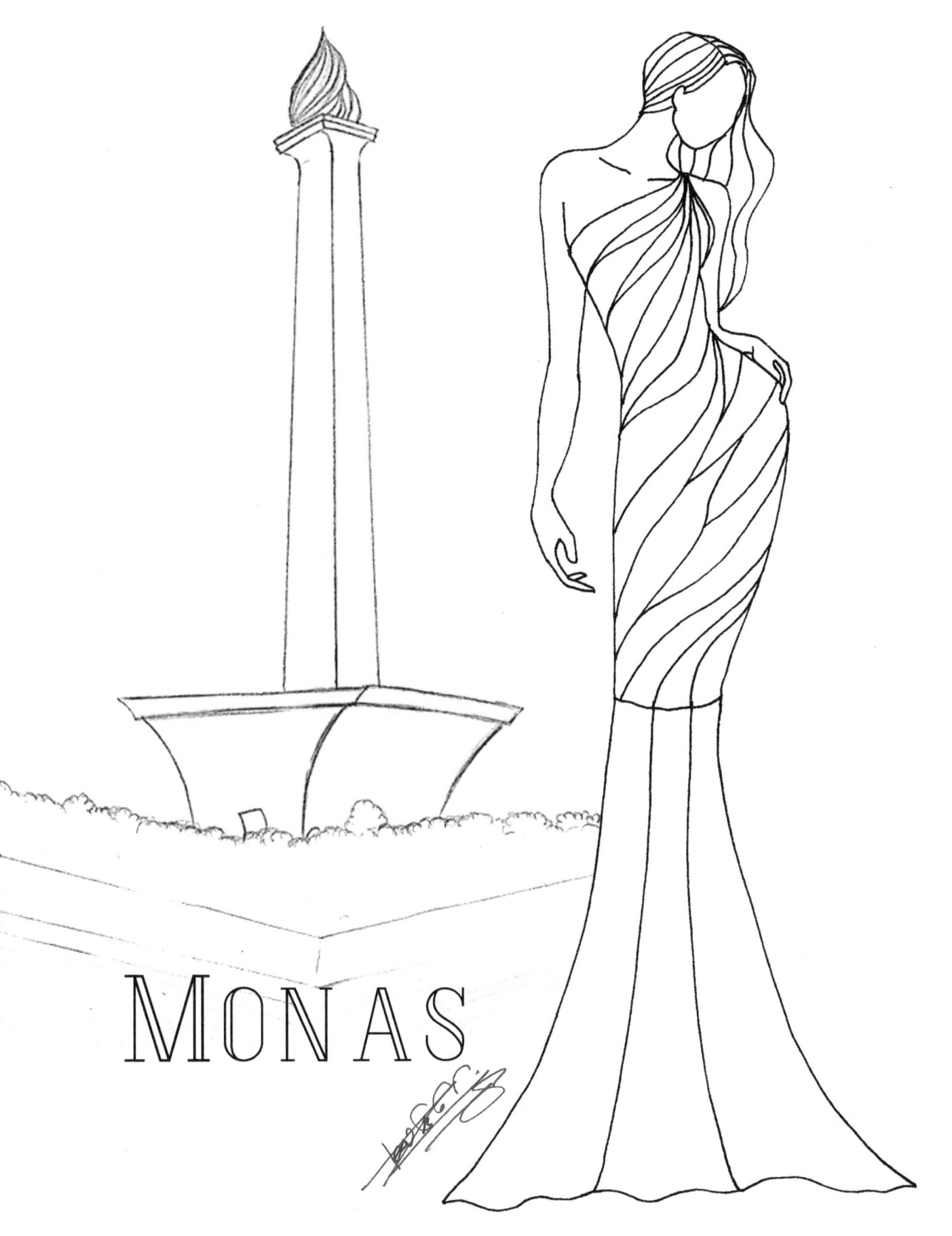

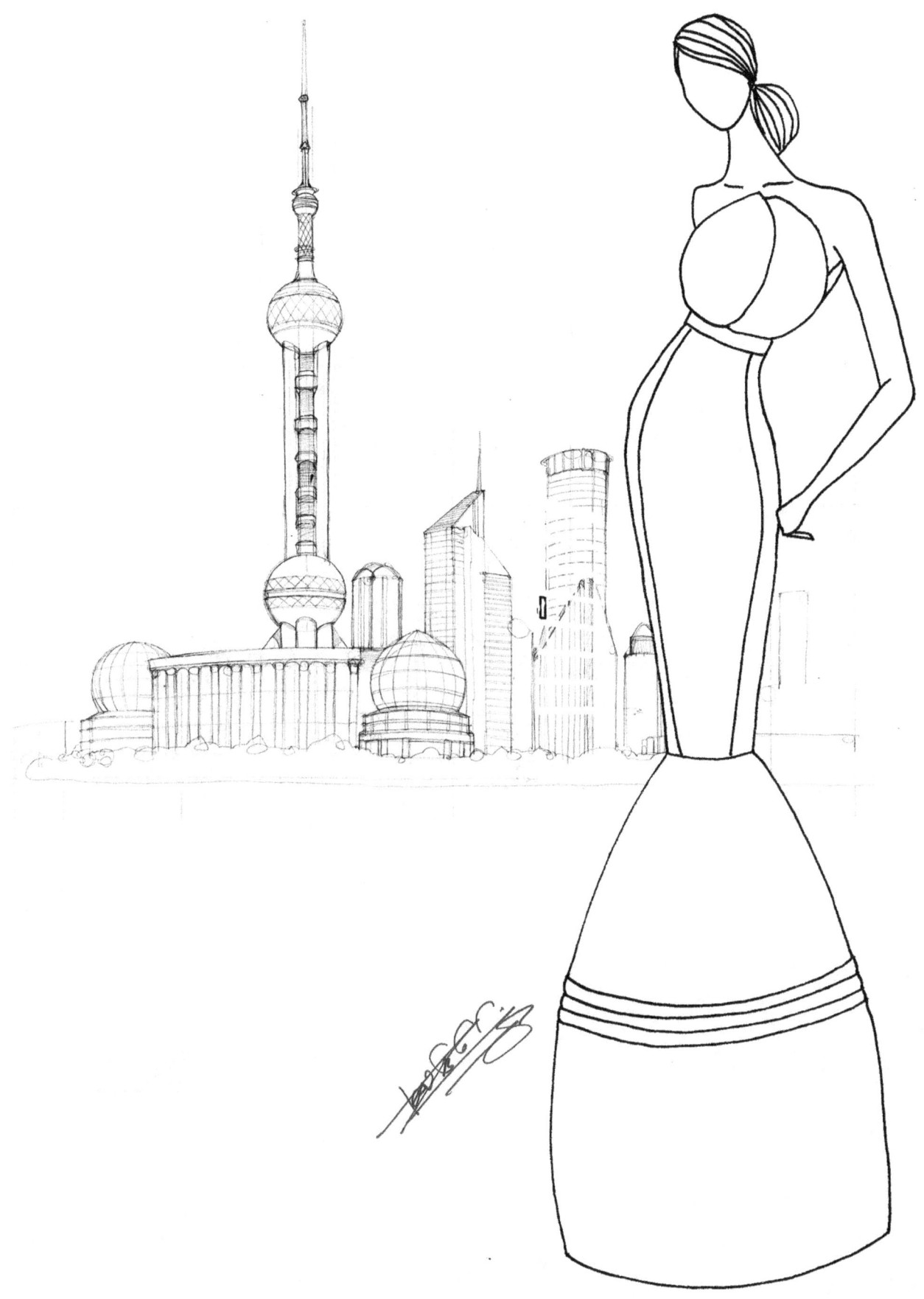

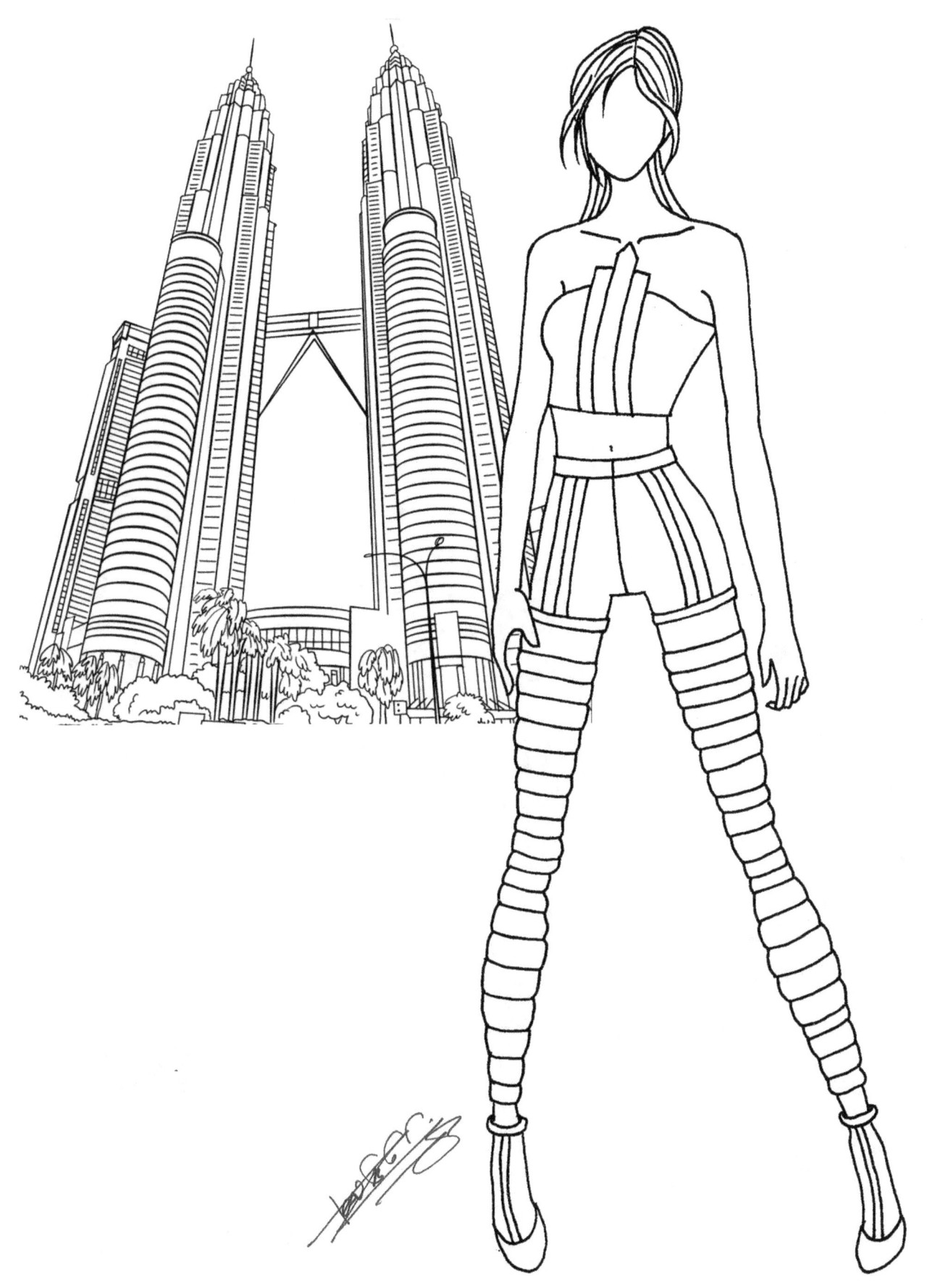

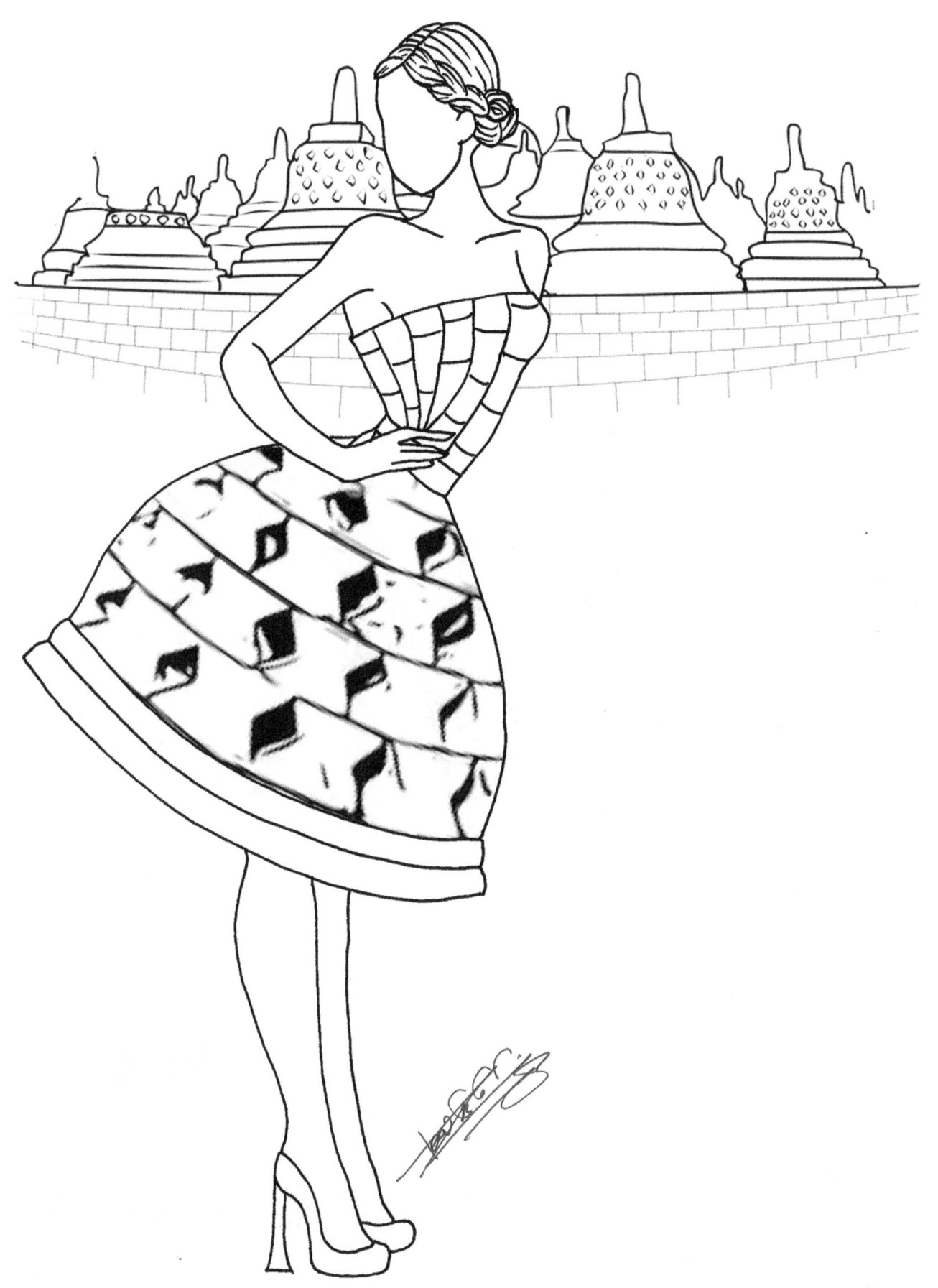

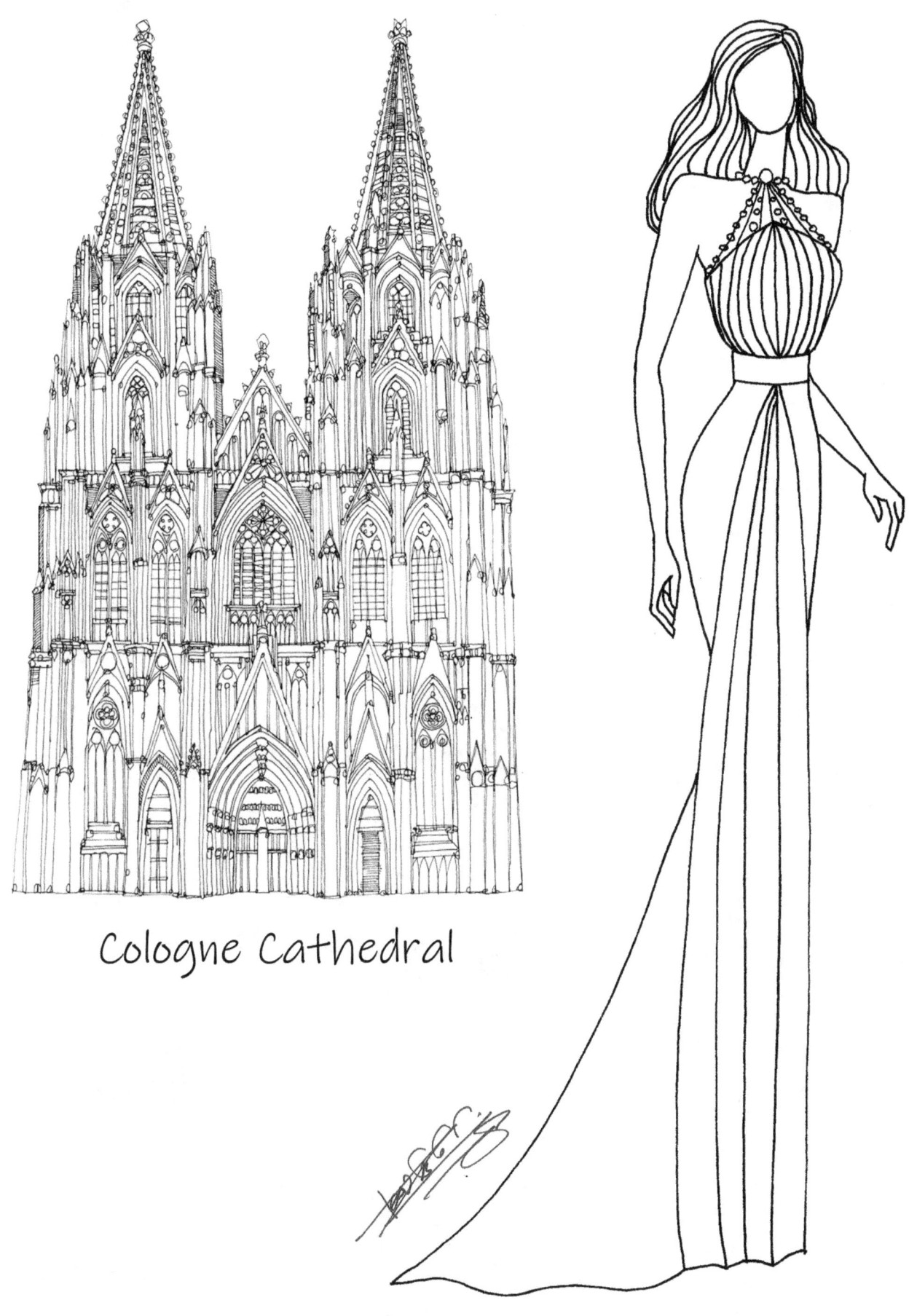

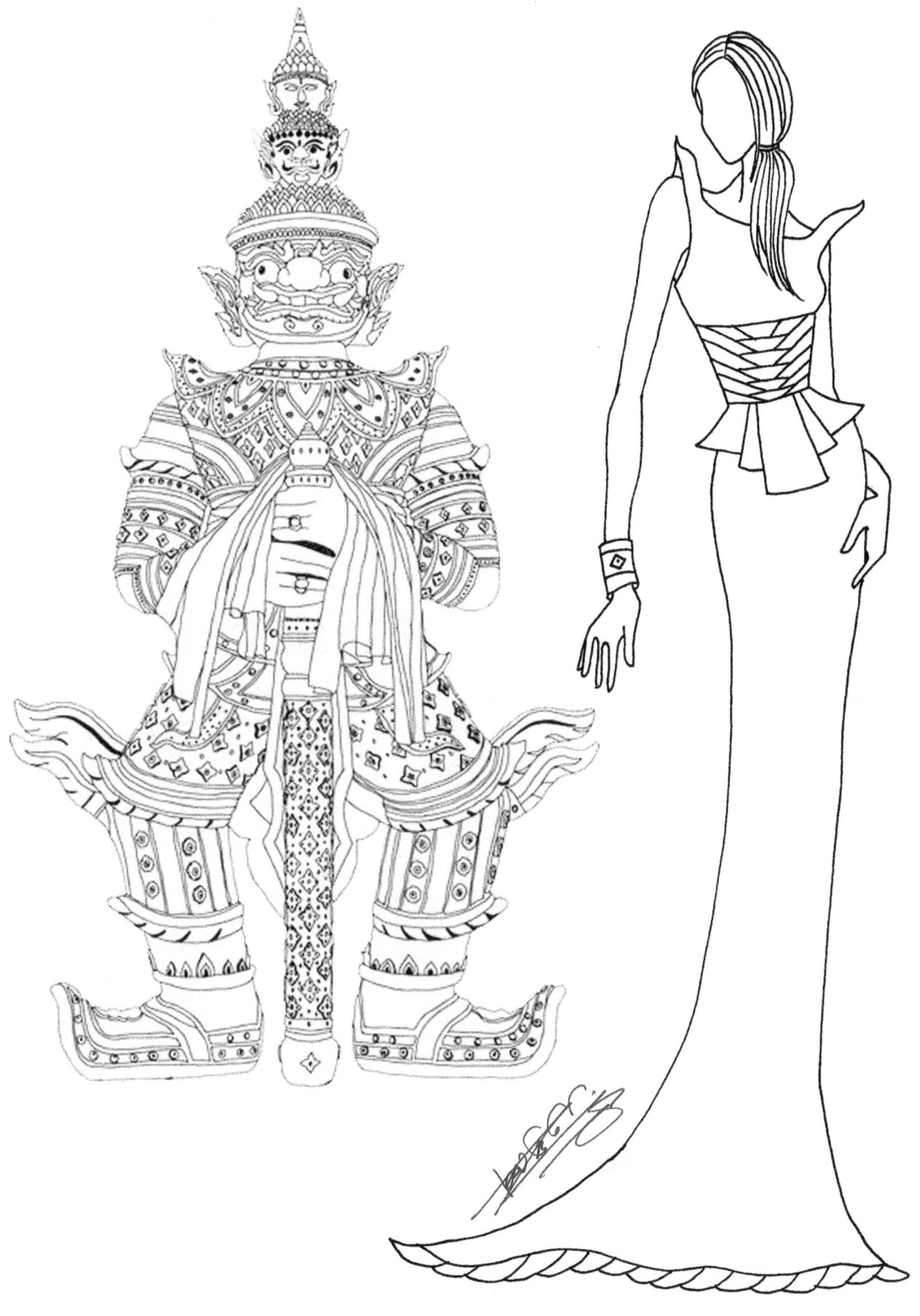

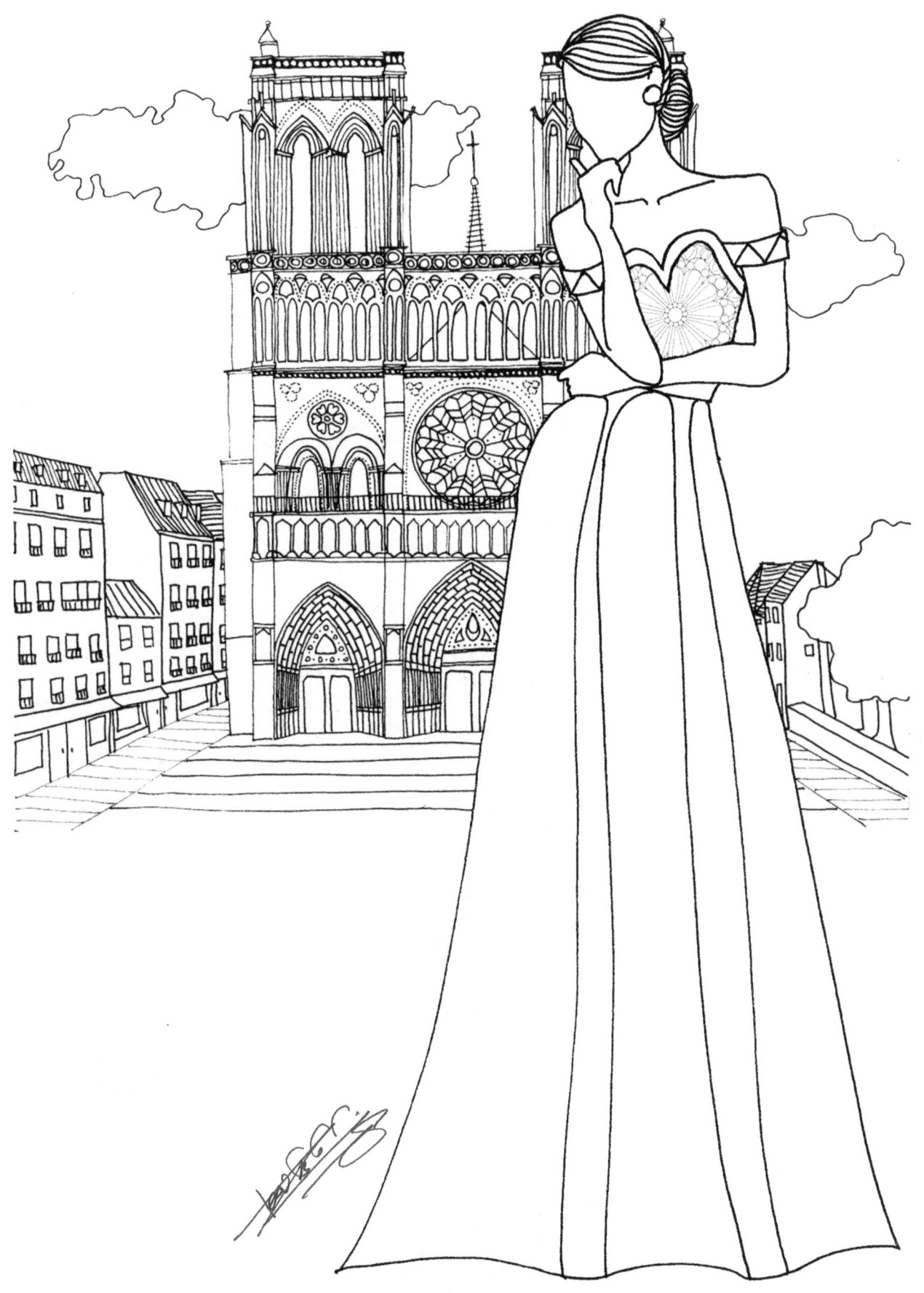

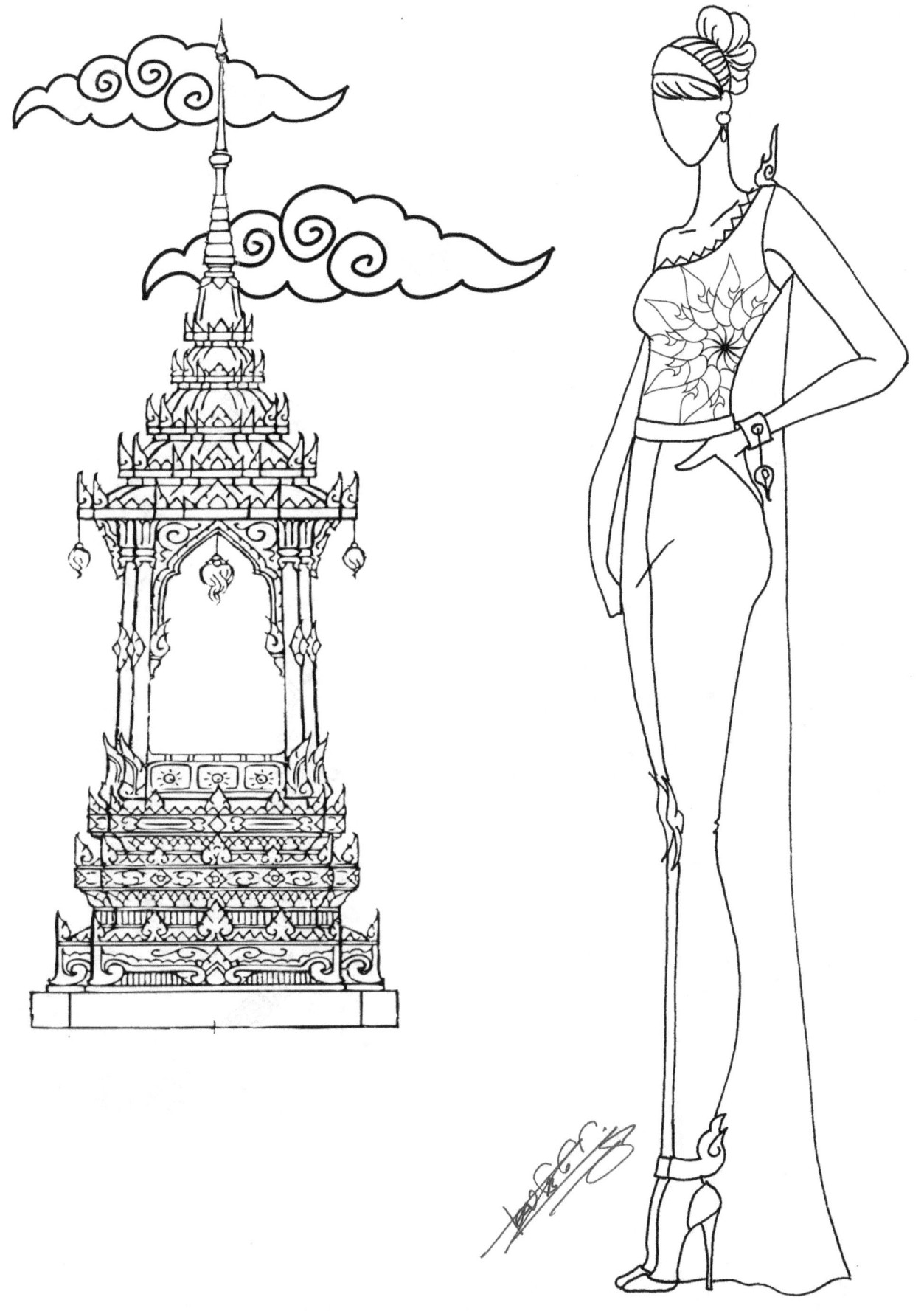

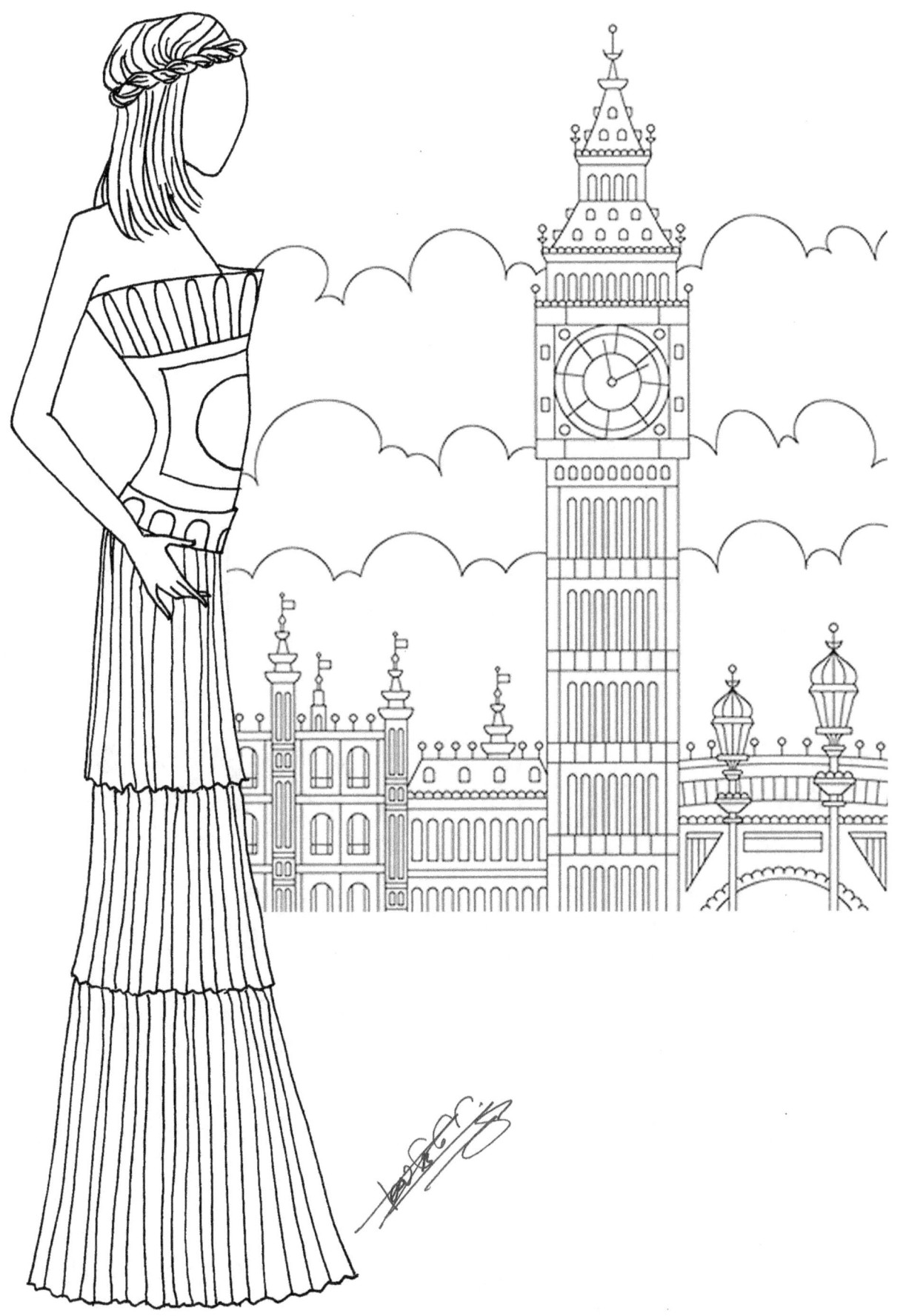

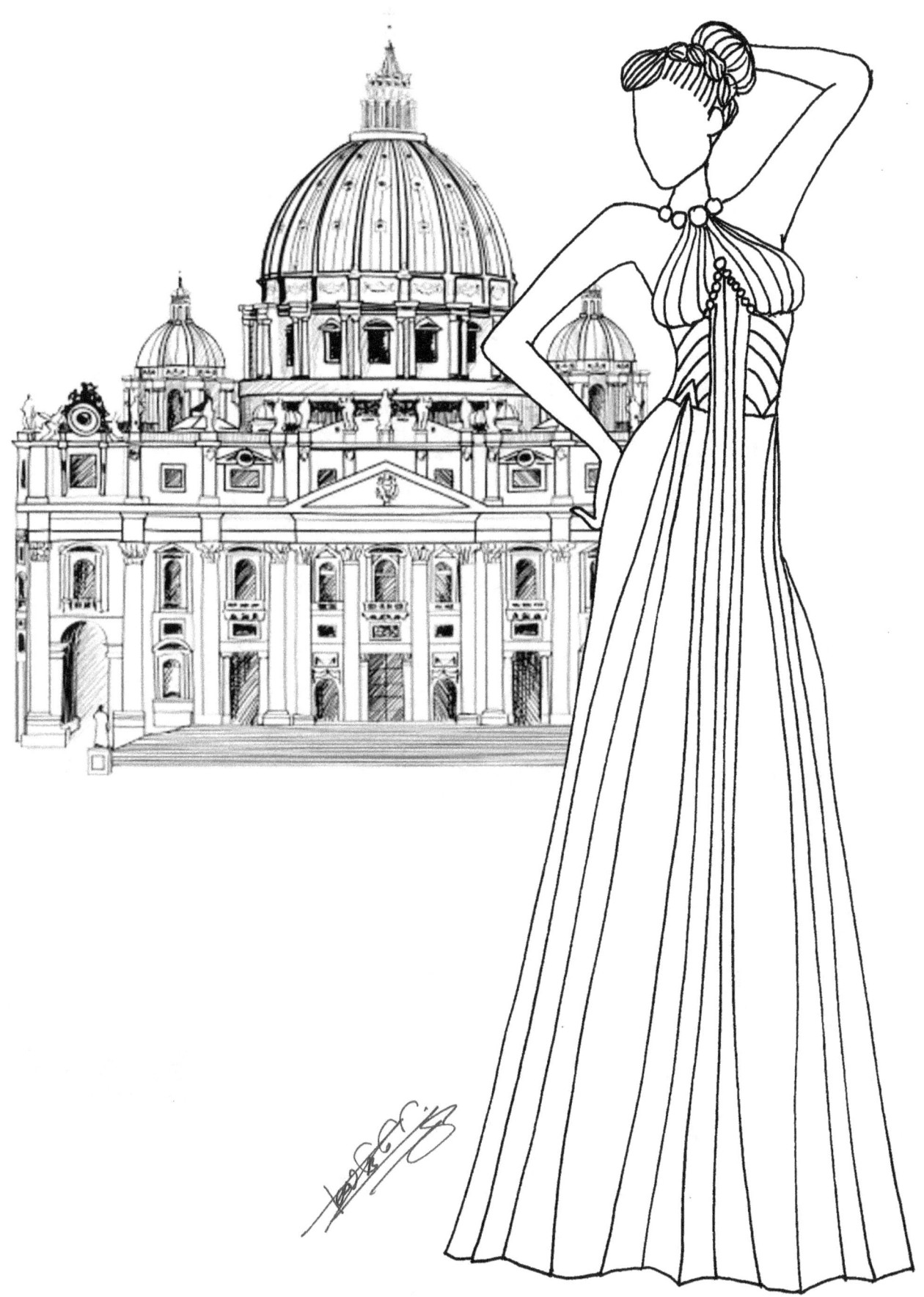

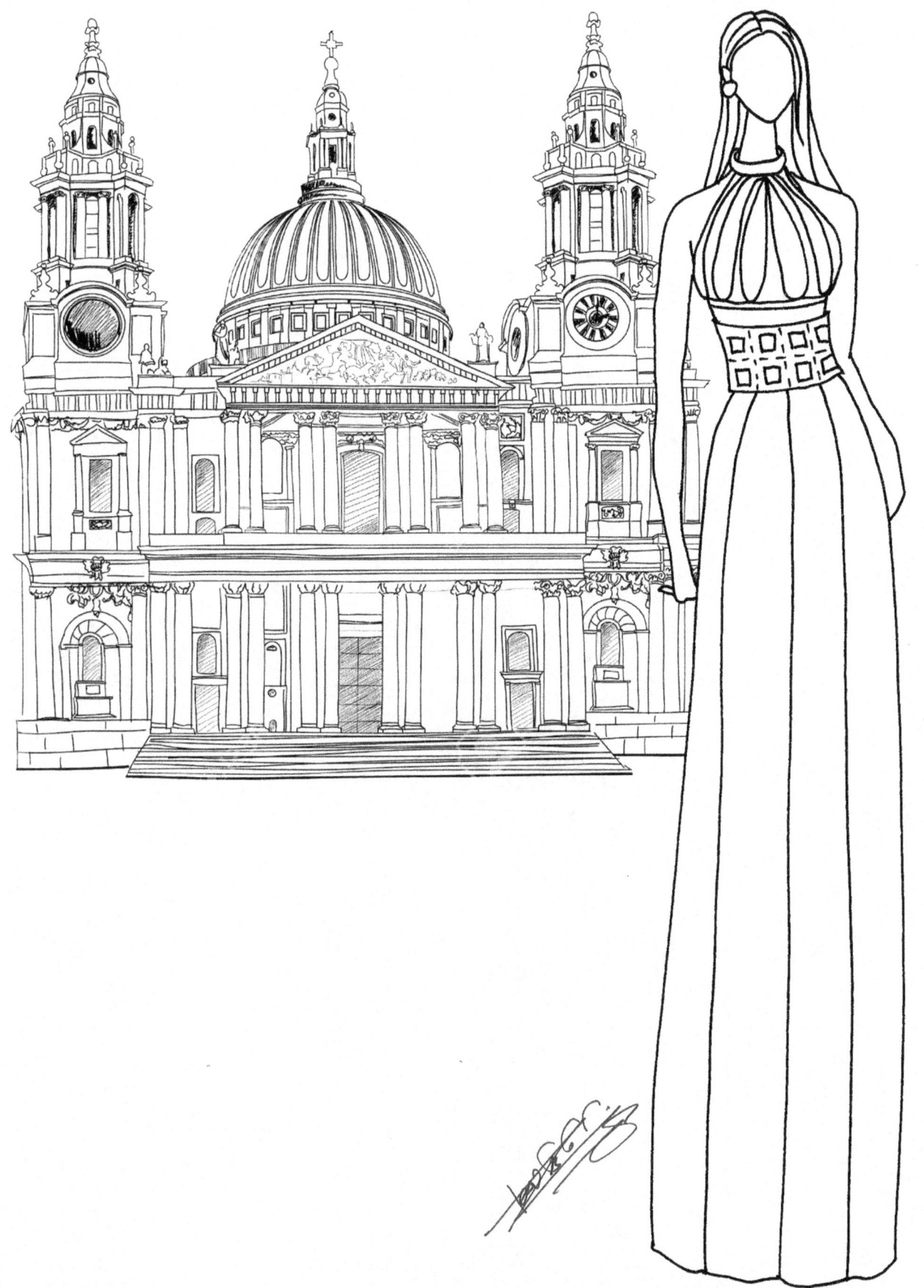

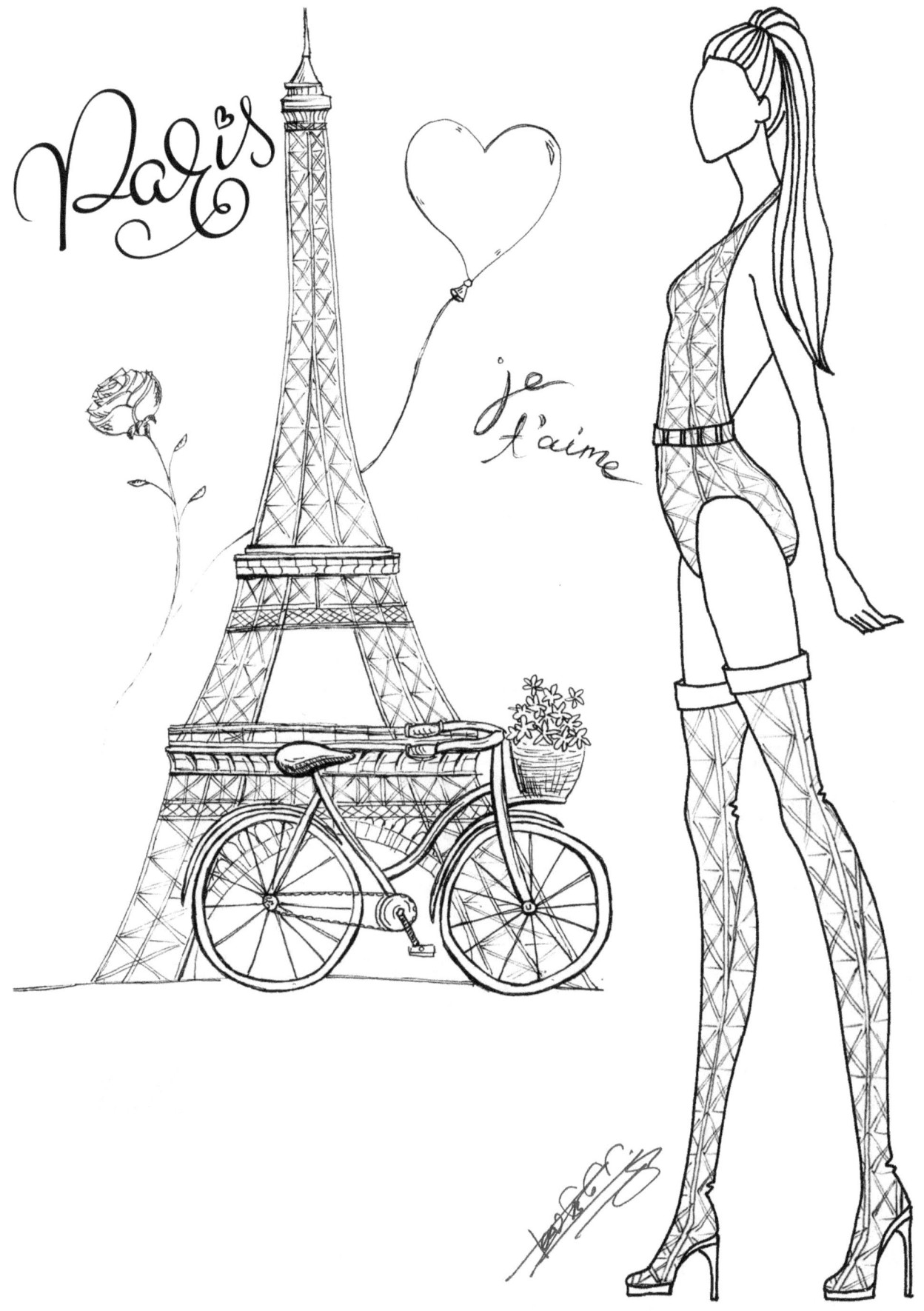

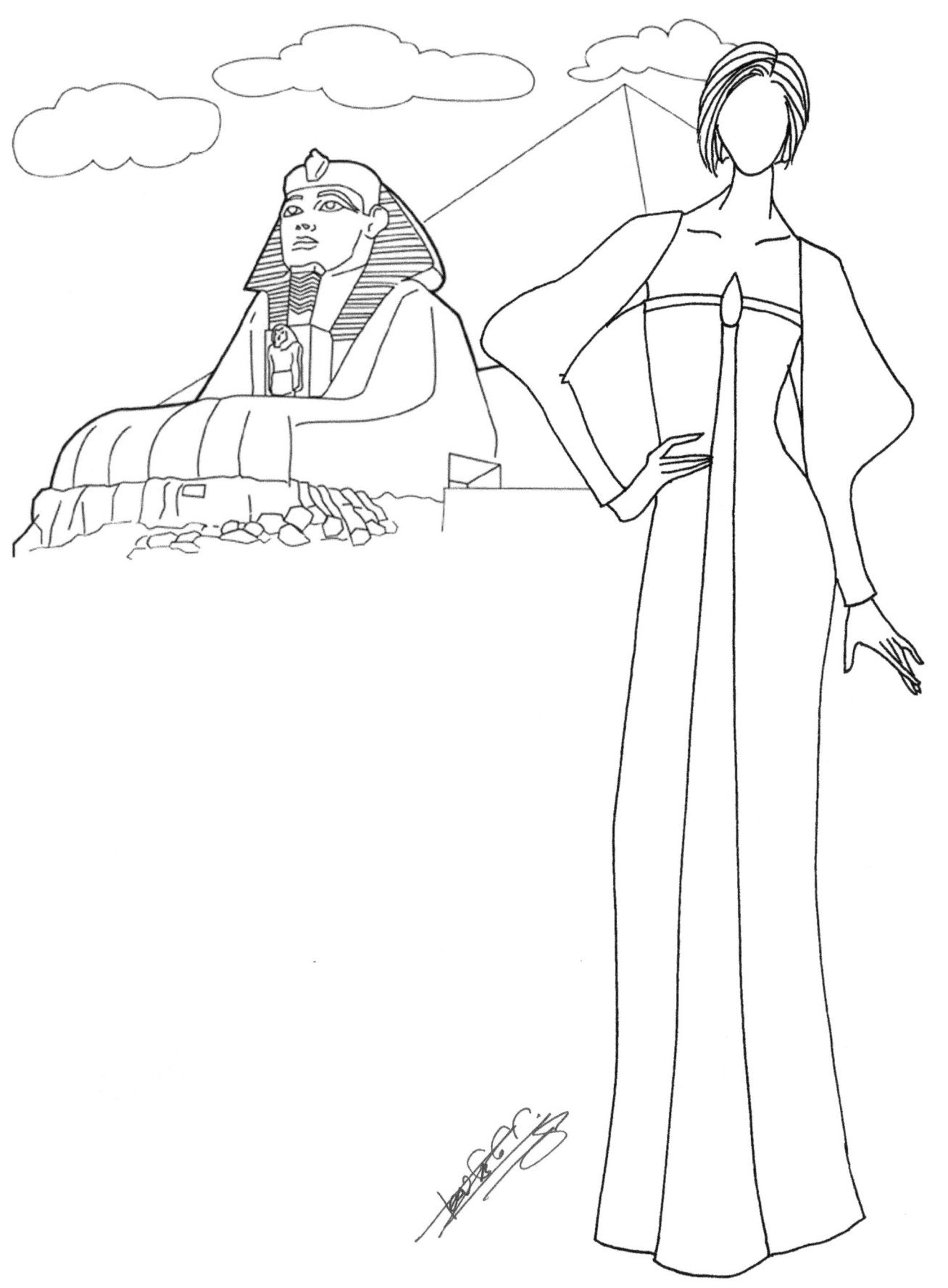

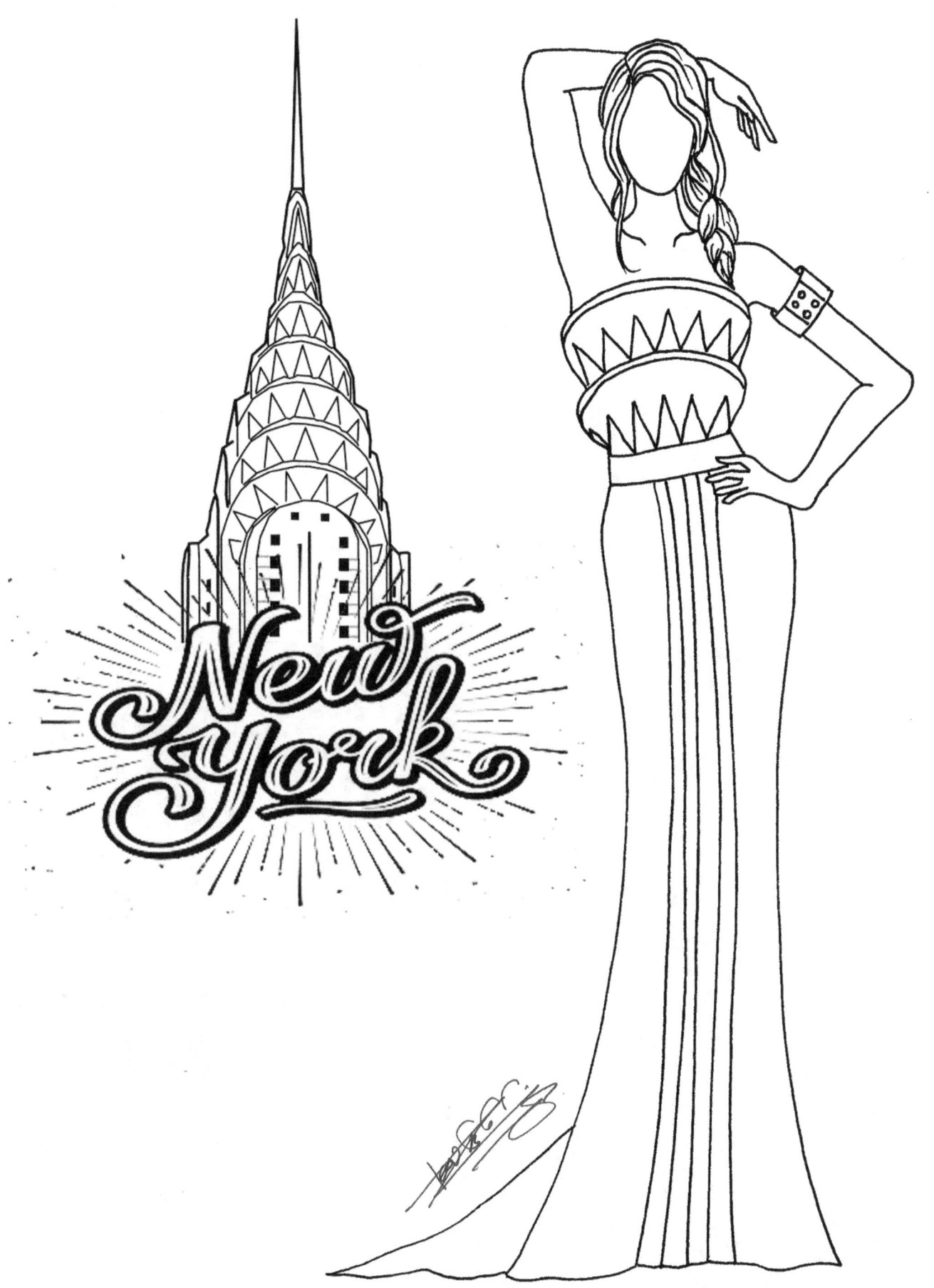

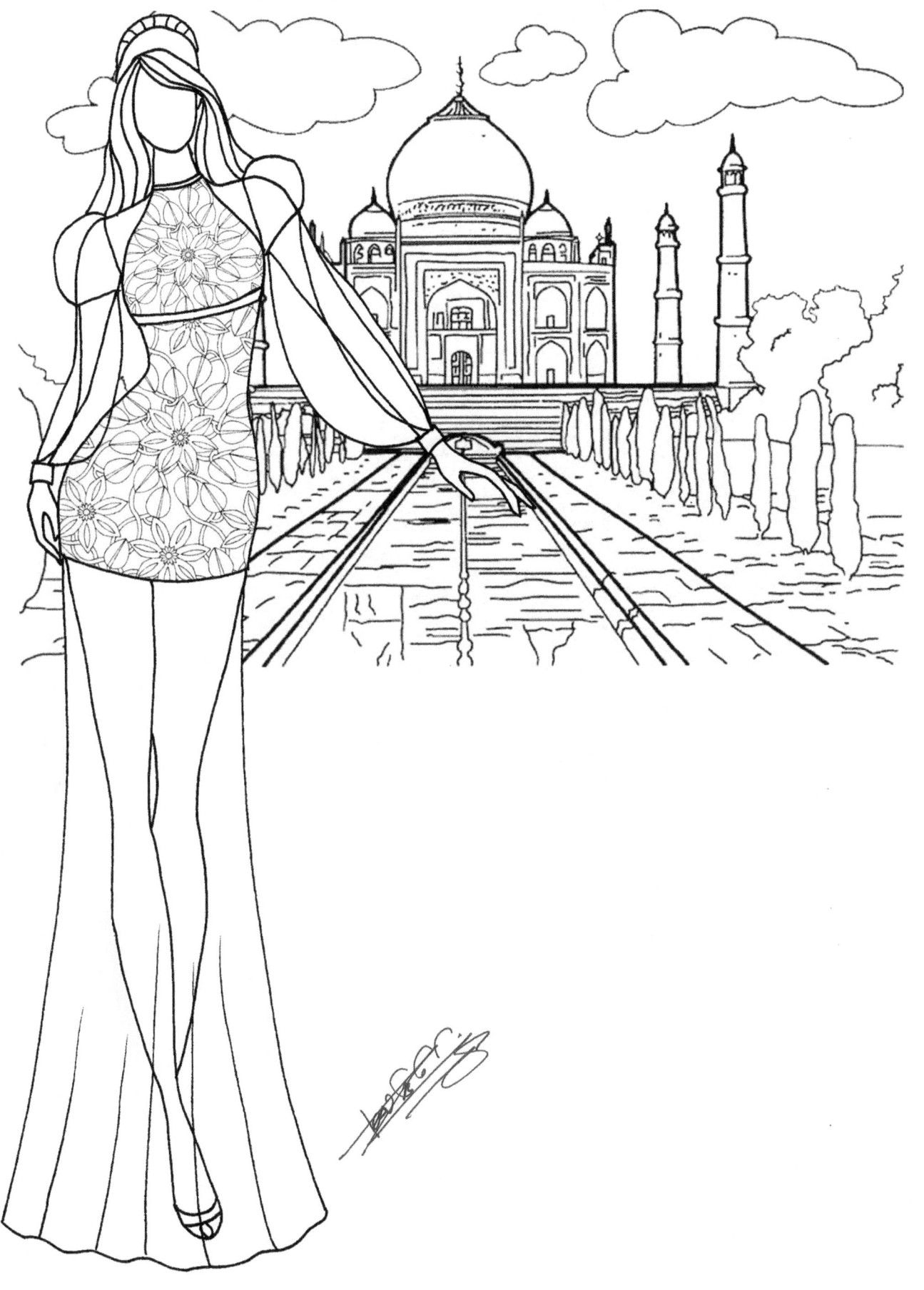

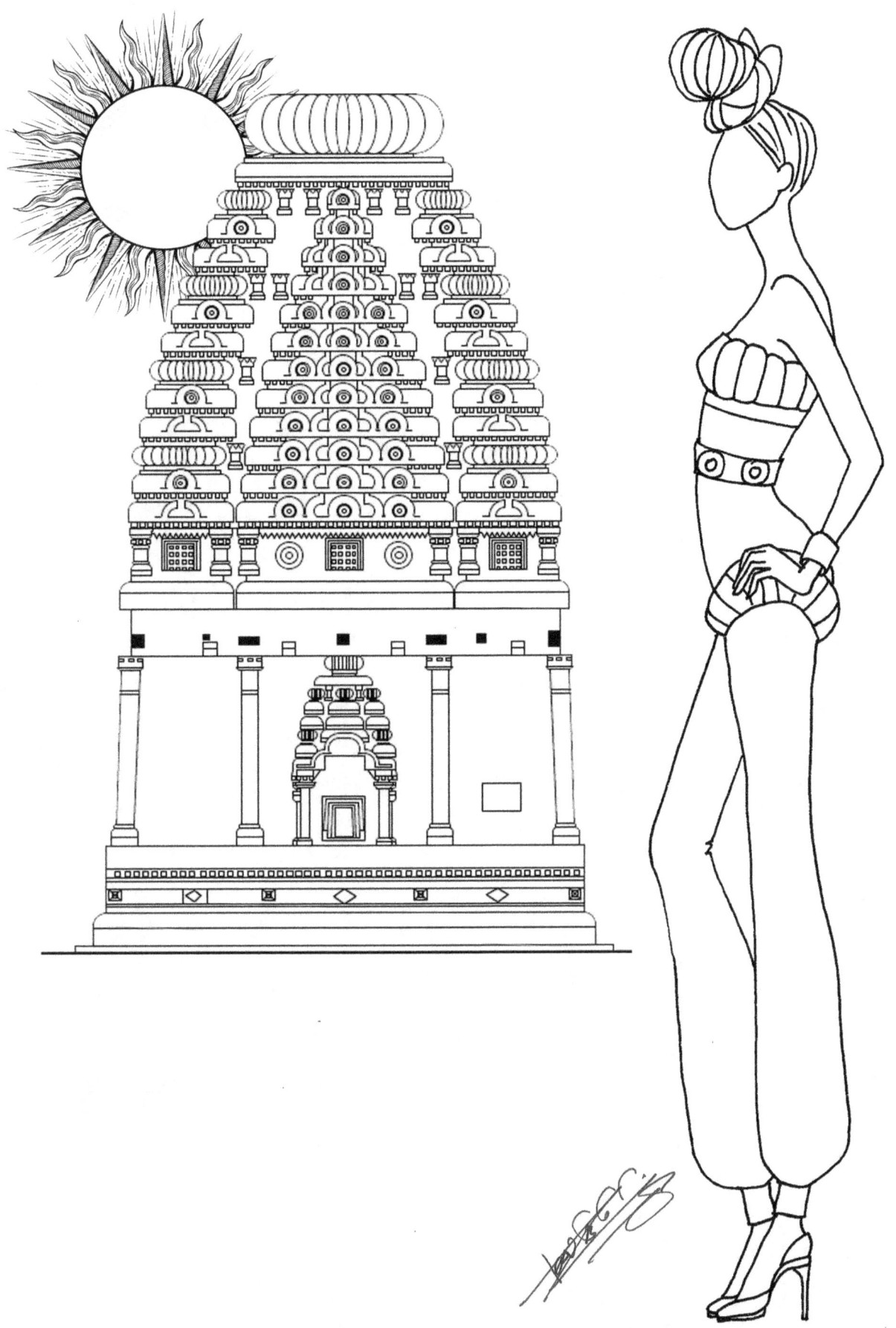

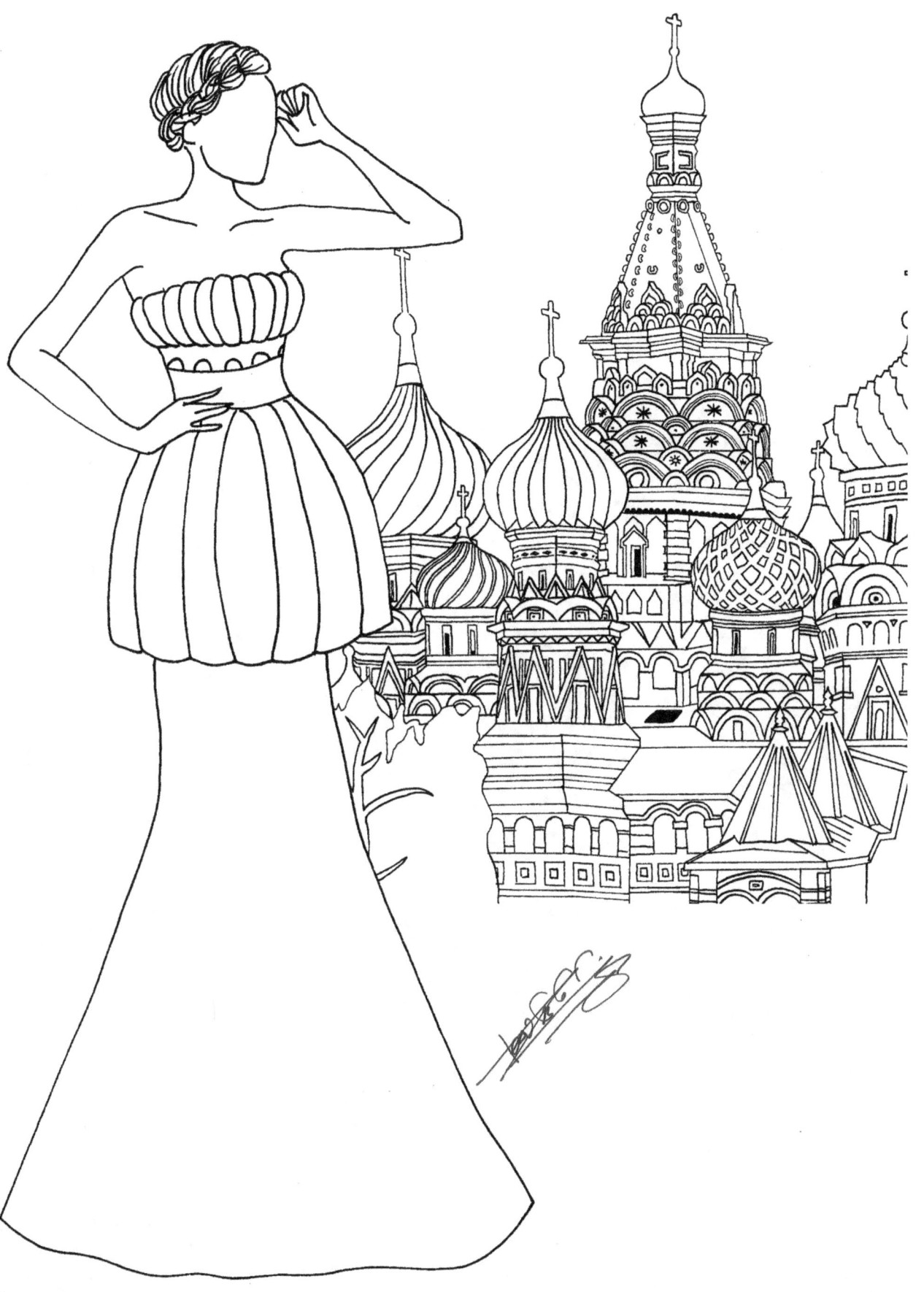

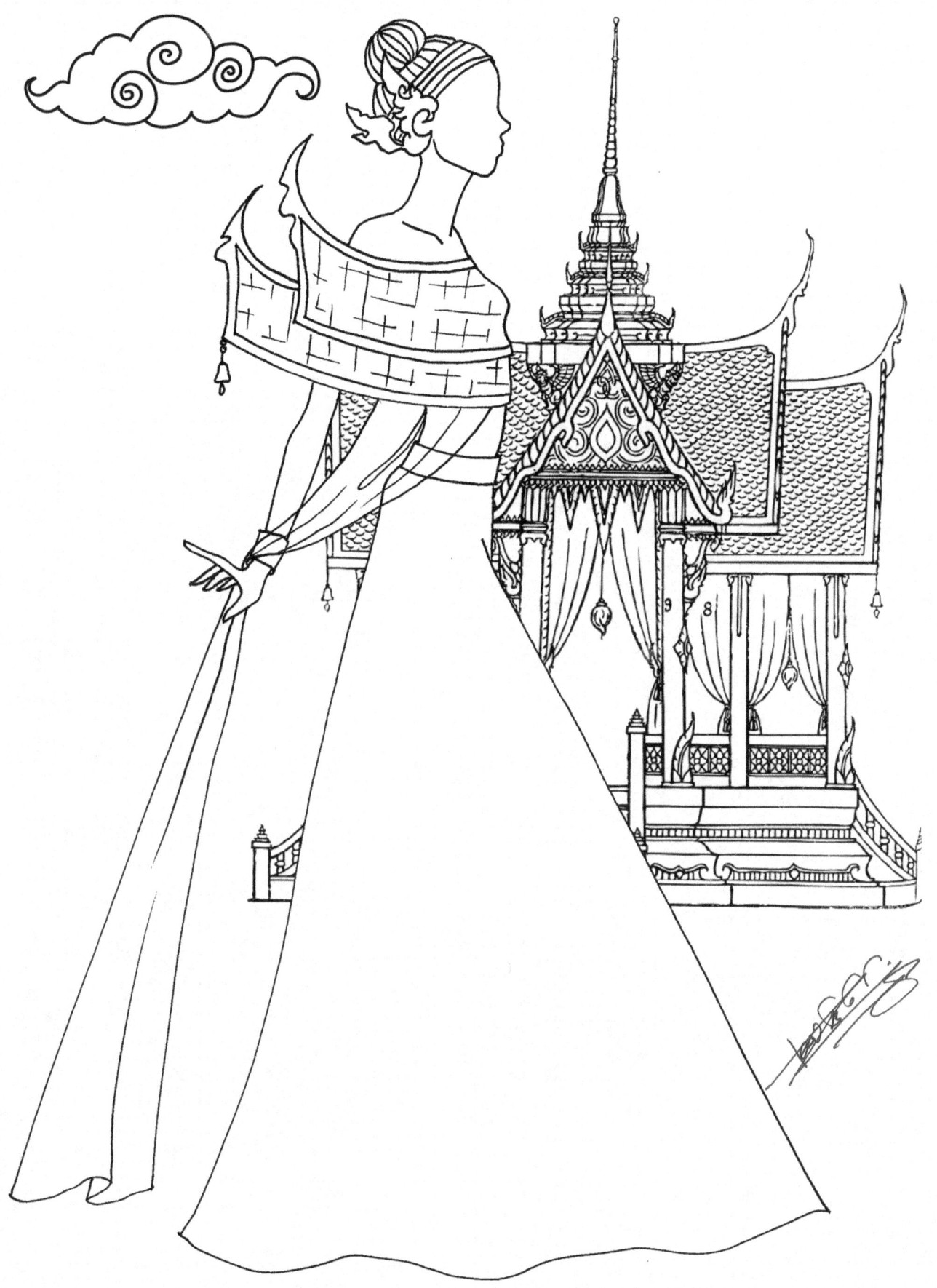

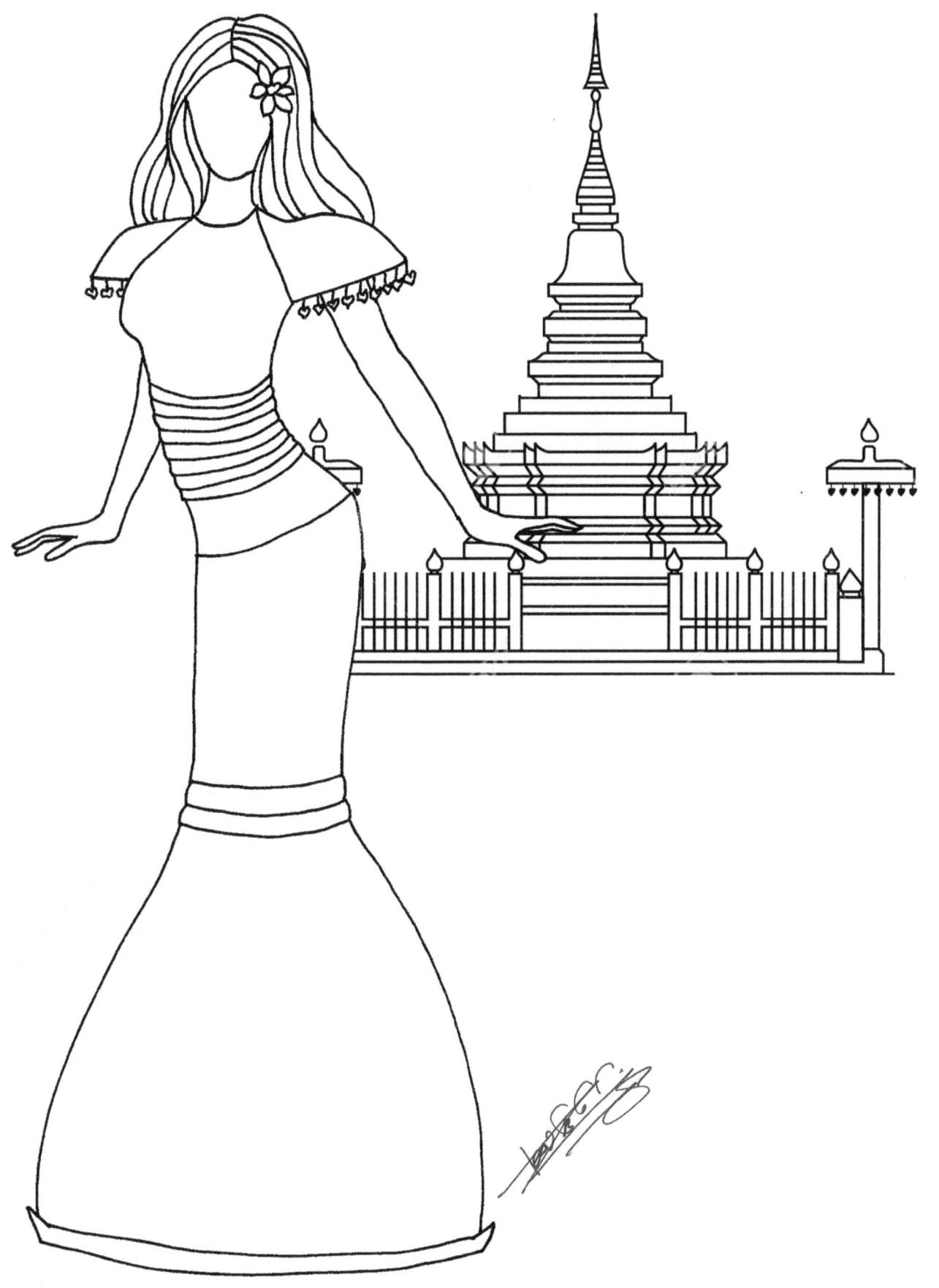

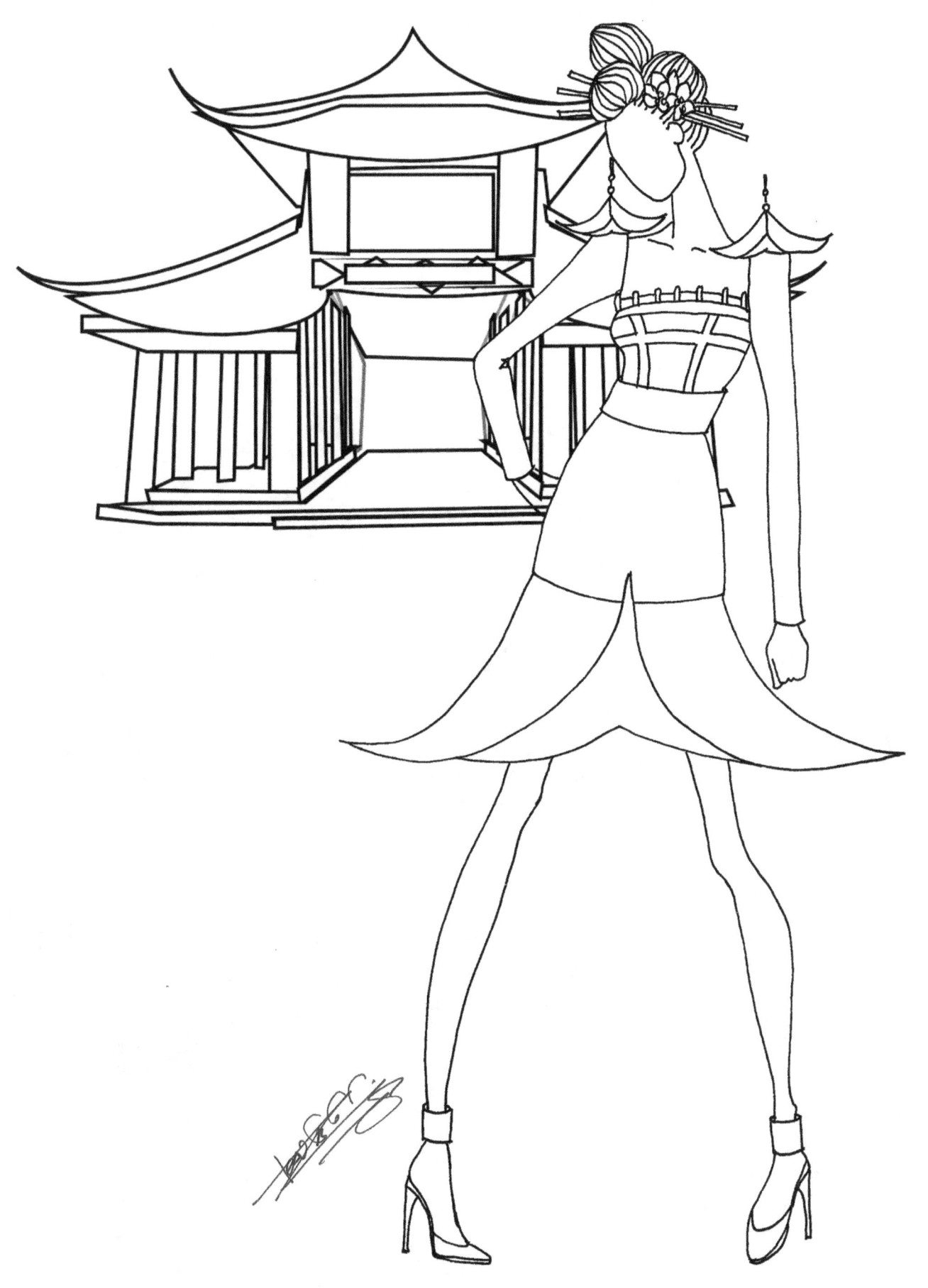

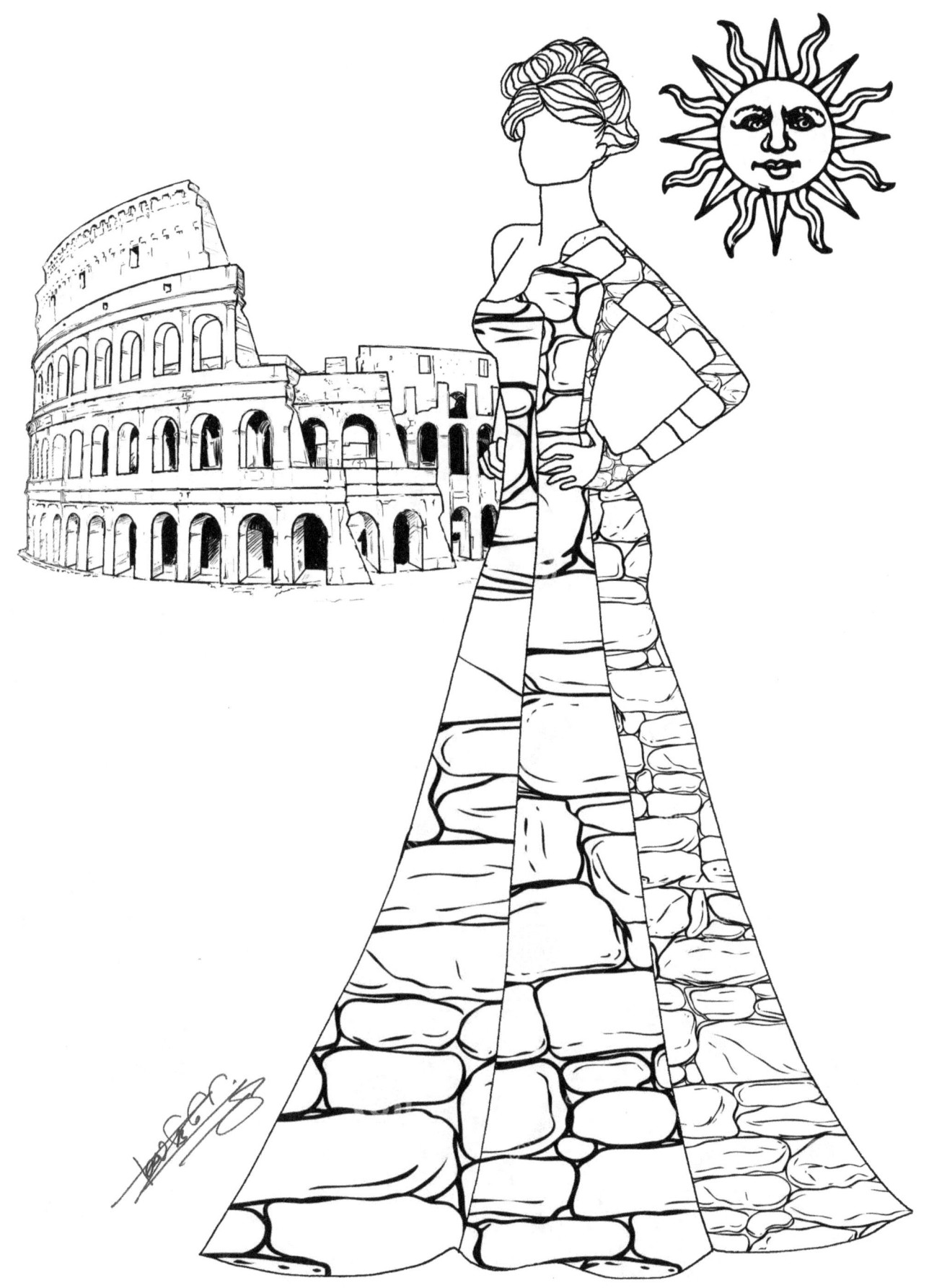

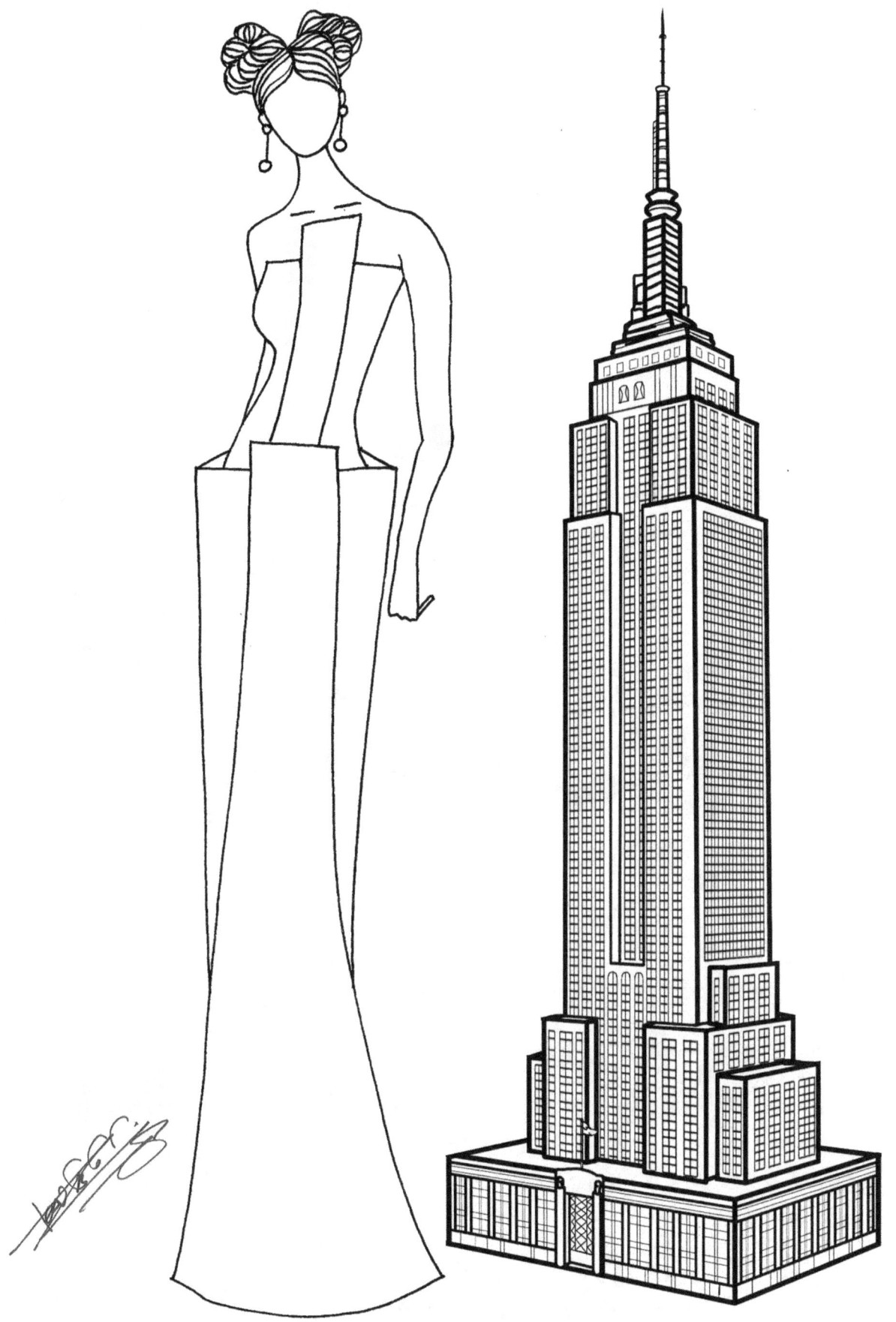

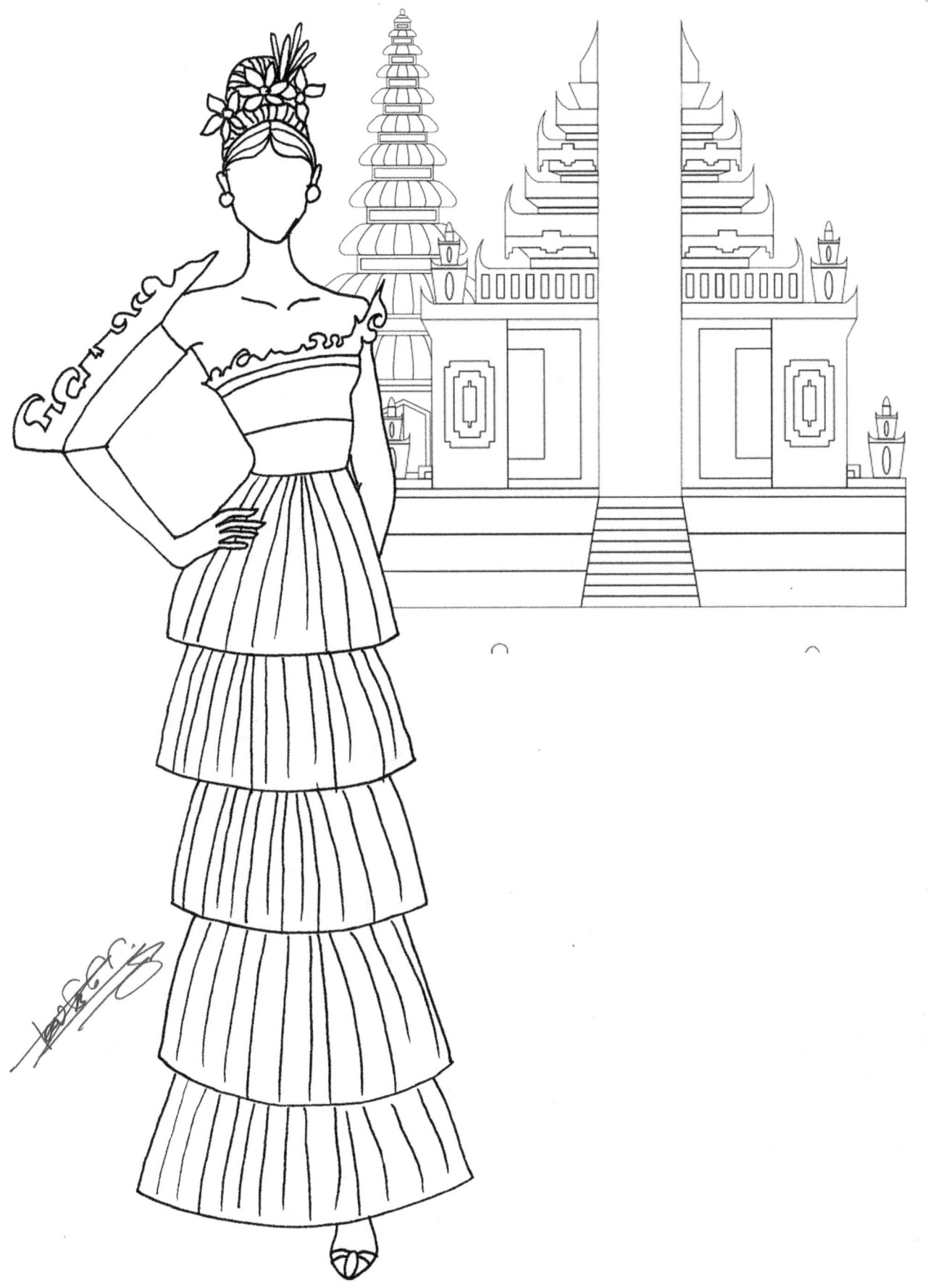

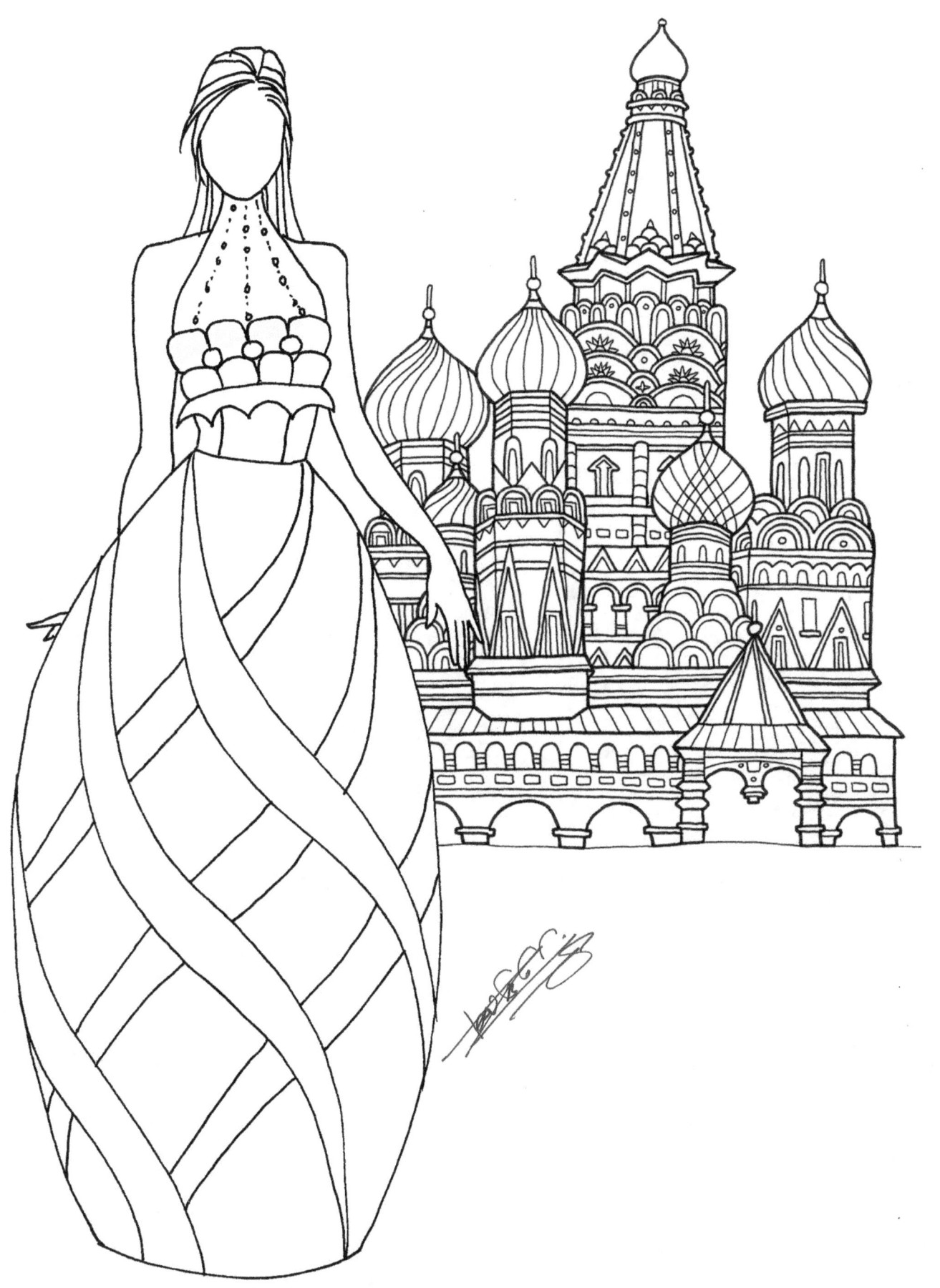

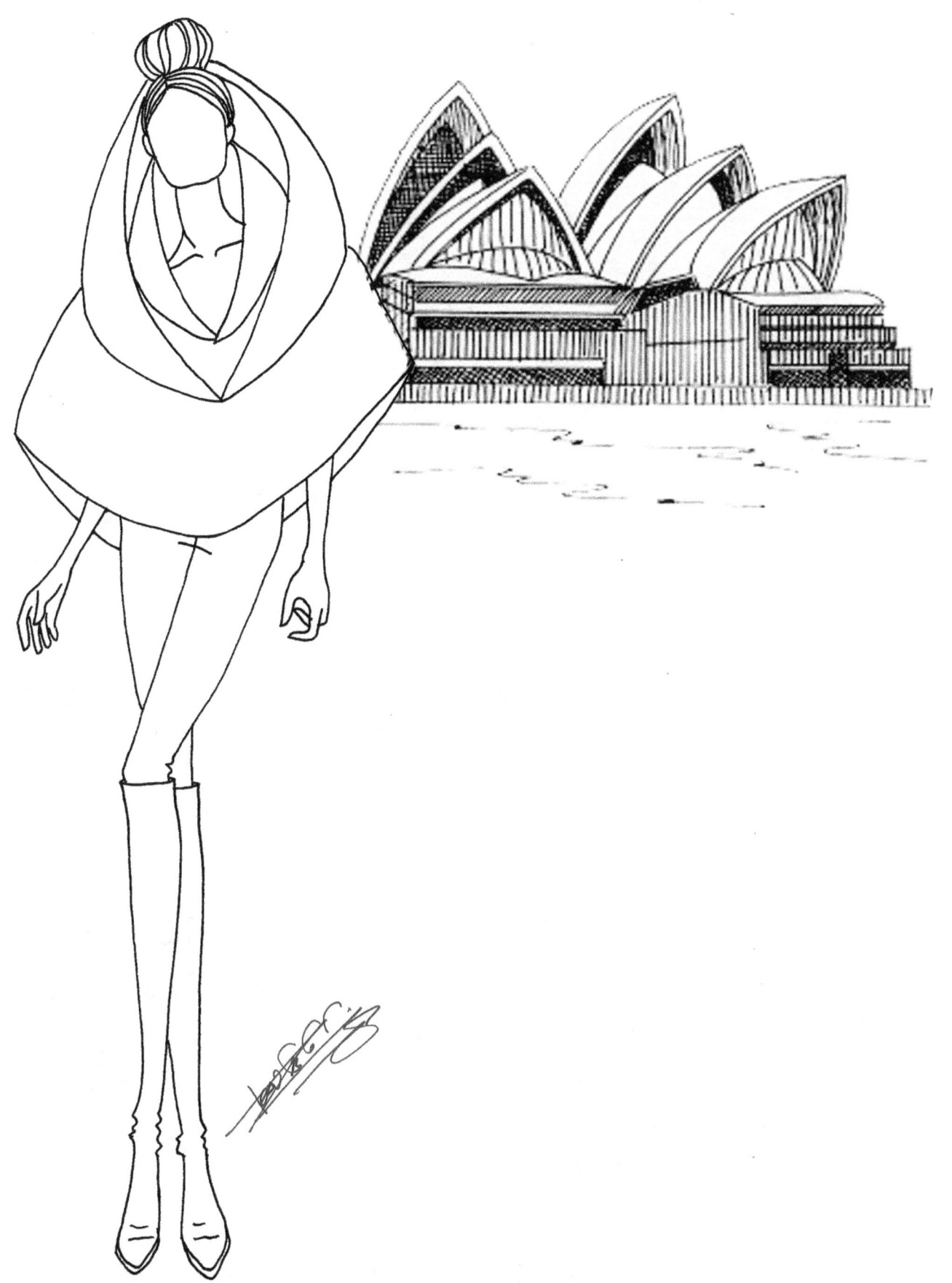

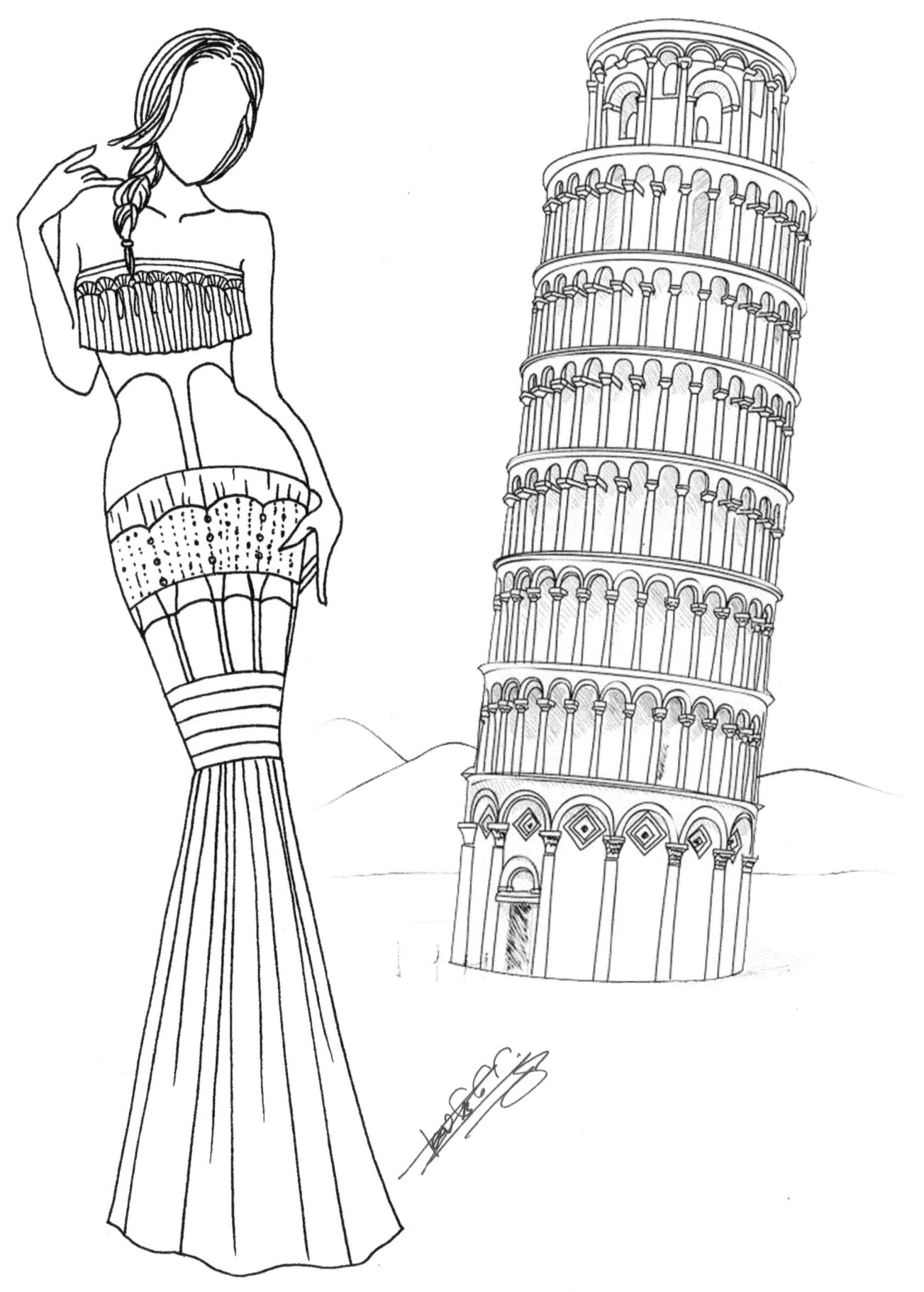

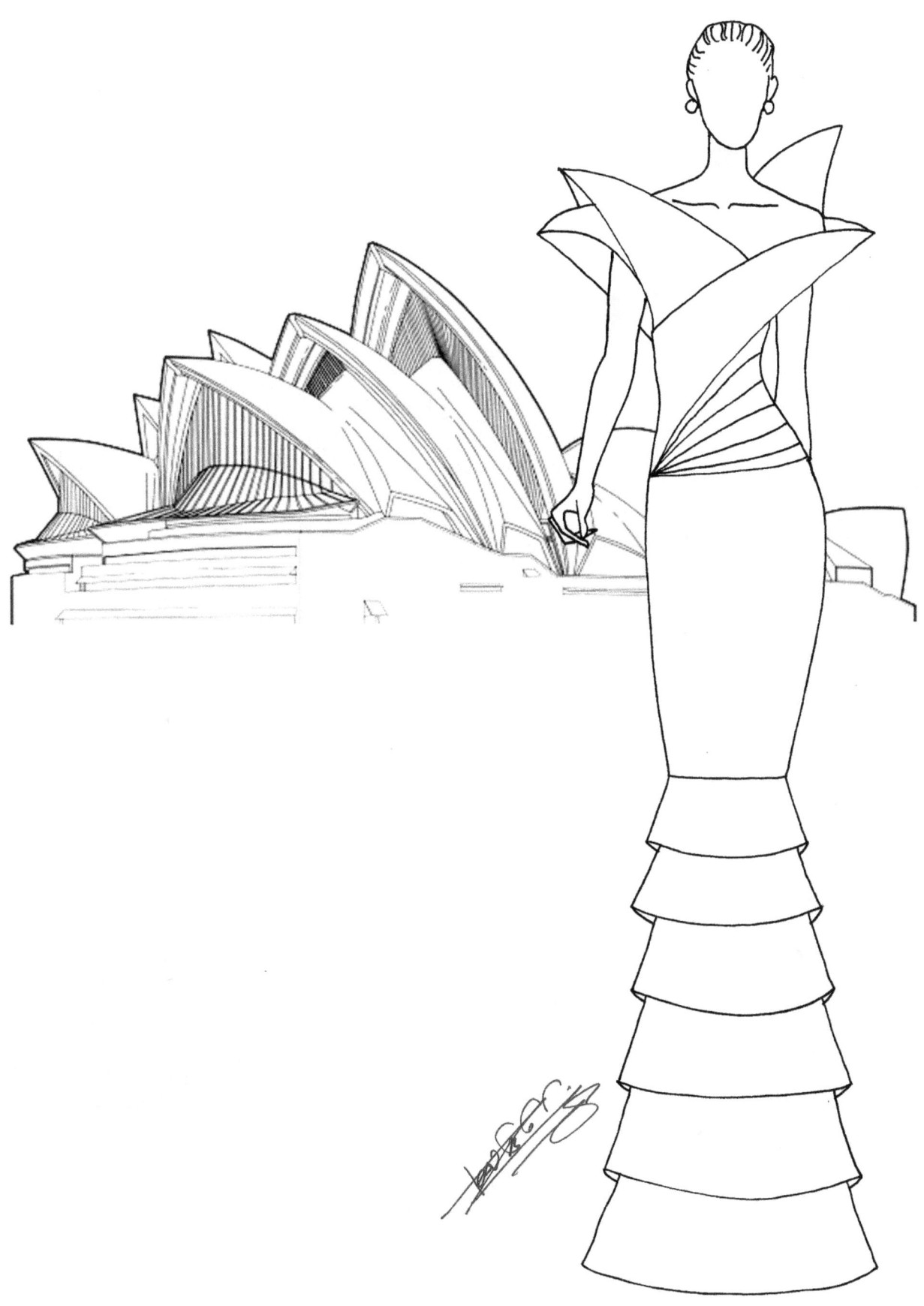